DAUBIGNY AND IMPRESSIONISM

DAUBIGNY AND IMPRESSIONISM

FRANCES FOWLE

NATIONAL GALLERIES OF SCOTLAND
EDINBURGH
2016

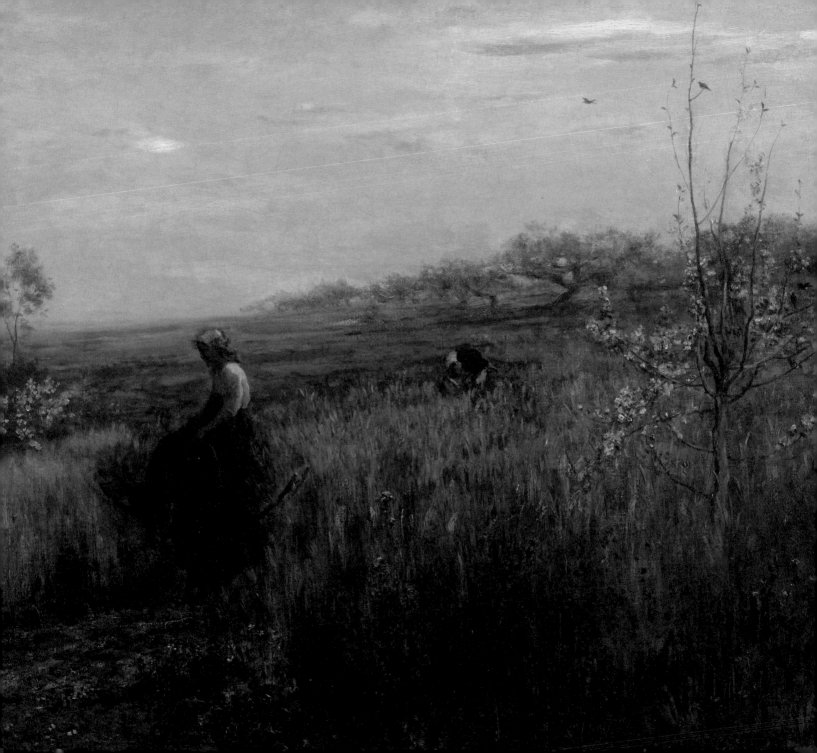

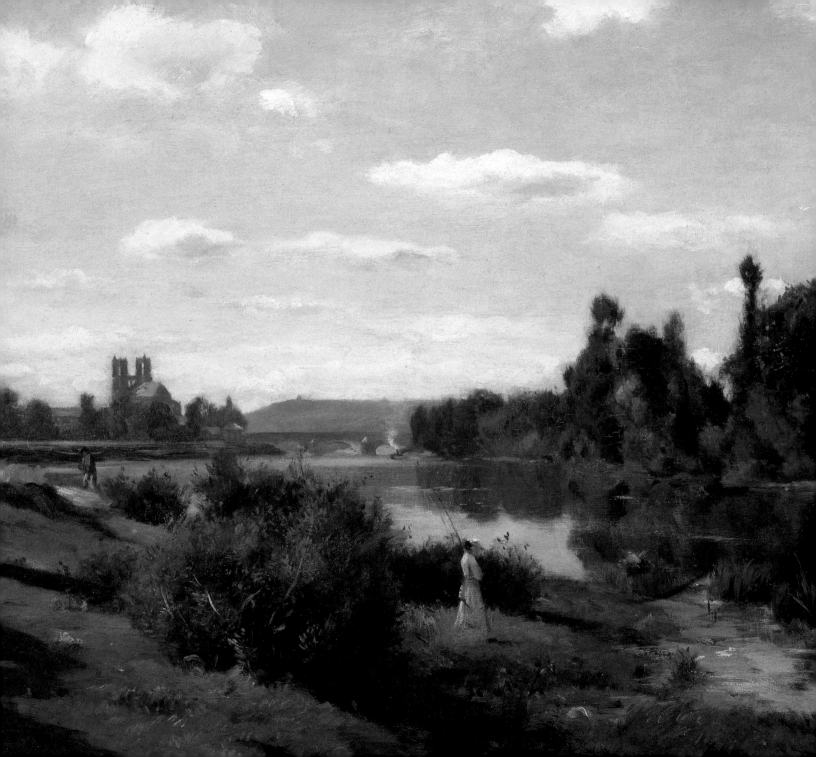

Daubigny and Impressionism

Known today for his atmospheric views of the River Oise, Daubigny was a pioneer of modern landscape painting and an important precursor of French Impressionism. Although commercially highly successful, he was often criticised for his broad, sketch-like handling and unembellished view of nature, and was dubbed the leader of 'the school of the impression'.[1] Indeed, in 1861 the writer Théophile Gautier complained that Daubigny 'contents himself with an *impression* and so neglects the details. His paintings … offer only juxtaposed patches of colour.'[2] As a result he drew the attention of the young Impressionists and from the 1860s onwards his bold approach to technique and composition inspired artists such as Claude Monet and Camille Pissarro, while his house and studio at Auvers-sur-Oise became a pilgrimage site for the likes of Berthe Morisot and Vincent van Gogh.

Daubigny: The Early Years

Born in Paris in 1817, Charles François Daubigny was the son of the landscape painter Edmé François Daubigny. A sickly child, the young Charles spent his childhood in Valmondois, a village on the River Oise north of Paris. He was brought up by Mère Bazot, a wet nurse, and developed a strong emotional bond with this region of France, to which he returned throughout his life.

Daubigny was keen to follow his father's profession and in 1835 he entered the studio of the academic painter Pierre Asthasie Théodore Sentiès. He also trained under the history painter Paul Delaroche, best known for his famous *Hemicycle*, 1841 (Ecole des Beaux-Arts, Paris), a mural representing artists through the ages. From the outset Daubigny was interested, like his father, in landscape painting, which had acquired a new status through the recent establishment of a special prize for 'Historical Landscape'. He competed twice for the coveted award, which allowed the winner to study at the French Academy in Rome. Although unsuccessful, he did make one early trip to Italy, accompanied by his friend the artist Henri Mignan.

Inspired by illustrious precursors such as Claude Lorrain and Nicolas Poussin, French landscape artists of the 1830s specialised in serene and harmonious views, often evoking classical texts. They were concerned with capturing precise atmospheric effects and often worked out of doors, in order to enhance the naturalism of their paintings. In 1800 the influential French artist Pierre Henri de Valenciennes had published an important treatise, which endorsed this practice. He urged artists to sketch in oils out of doors (*en plein air*) in all seasons so as to 'seize Nature as she is'.[3] Artists were aided by the invention, in 1841, of the collapsible or squeezable paint tube, which replaced the

awkward and messy pigs' bladders that they had previously used to store paint. As the century progressed, the fashion for *plein-air* painting gathered pace, not only in France, but also in other parts of Europe.

In 1843 Daubigny began working out of doors in the Forest of Fontainebleau, where a group of painters, later known as the Barbizon School, was forming under the leadership of Théodore Rousseau and Jean François Millet. These artists espoused a more naturalistic response to landscape painting and preferred to depict peasants working in the forest or on the plain at Chailly, rather than focus on historical academic subjects. Daubigny befriended Rousseau and Jules Dupré and soon began working alongside Dupré at L'Isle Adam in the Oise Valley, close to his childhood home at Valmondois. One of his earliest oil sketches shows a painter, shaded by a white parasol, sketching in oils at the edge of the wheatfields above the nearby village of Auvers-sur-Oise, where he would eventually settle.

Initially Daubigny adopted an academic approach, painting with small brushes and paying close attention to detail and finish. Before long, however, he developed a more experimental technique, often working with a palette knife, brightening his colour range and aiming for different atmospheric effects. Daubigny quickly attracted the attention of the critics and in 1859 *Banks of the Oise* (fig.1), one of

his submissions to the annual Salon, was widely praised for its realism. The artist was hailed as the leader of a new type of landscape painting which emphasised truth to nature, rather than historical associations.

Two years previously Daubigny had fitted out a unique floating studio, adapted from an existing boat, and familiarly known as the *Botin* (fig.2). It enabled him to paint out of doors on the river and to depict nature in all her splendour from mid-stream. In 1860 he established himself at Auvers, a picturesque village north-west of Paris, situated on the River Oise and surrounded by vineyards and wheatfields. Despite its proximity to Paris, Auvers had remained remarkably unspoiled, its narrow streets lined with tumbledown thatched cottages and populated by local peasants who still made their living from the land. What attracted him primarily, however, was the village's situation on the river, enabling him, travelling on his studio boat, to visit with ease the neighbouring villages of Pontoise, Eragny, Valmondois and the forest of L'Isle Adam. The writer Emile Zola recorded that Daubigny 'adored' the Oise valley, 'irrigated by numerous streams, its vegetation … softened by the silvery vapour of mist rising from the river'.[4]

Encouraged by his artist friend Camille Corot, Daubigny soon decided to build a house and studio at Auvers. The house, known as the 'Villa des Vallées',

1

Charles François Daubigny
Banks of the Oise, 1859
Oil on canvas, 88.5 × 182 cm
Musée des Beaux-Arts, Bordeaux

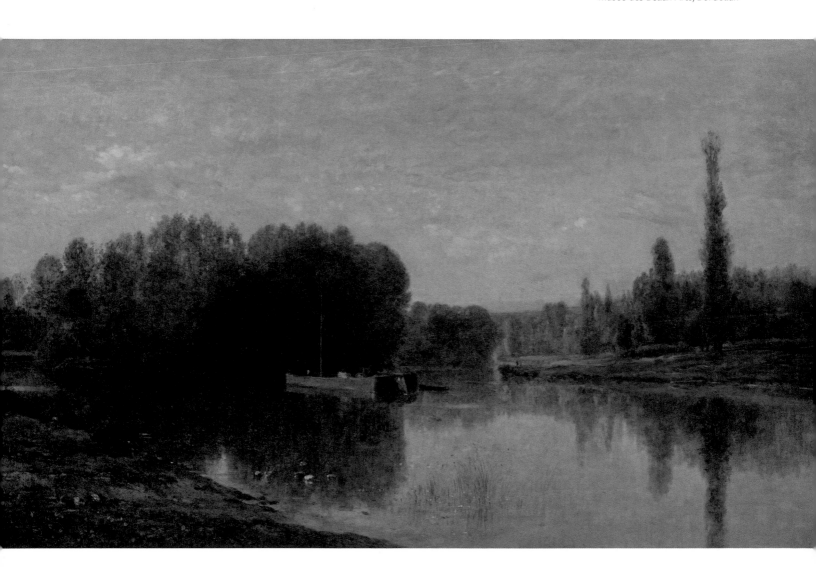

DAUBIGNY AND IMPRESSIONISM

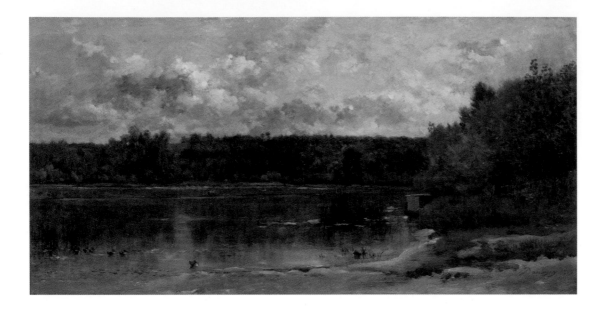

2

Charles François Daubigny
River Scene with Ducks, 1859
Oil on panel, 20.4 × 40 cm
The National Gallery, London
Salting Bequest, 1910

was completed in 1861, and decorated by Daubigny and his two children, Karl and Cécile. Corot designed landscape panels for the studio, and the artist Honoré Daumier, who lived nearby at Valmondois, produced a witty sketch of Don Quixote for the entrance hall. Daubigny was soon surrounded by friends and acolytes, among them Berthe Morisot and her sister Edma, who visited the villa in 1863. The Morisots had rented a house at Le Chou, a small hamlet between Pontoise and Auvers, and the sisters were working hard towards their first submission to the Paris Salon the following year.

At Auvers Berthe produced a river scene, painted at Le Valhermeil, whose oblique composition and evening light suggest the influence of Daubigny, even if her emphasis was very much on leisure and modernity: canoes on the river, a woman fishing from a bench and people strolling along the towpath. By contrast, Daubigny often edited out any contemporary references. An exception is a work such as *The River Seine at Mantes*, about 1856 (fig.3), which features a woman in modern dress in the foreground and a smoking factory chimney in the distance.

Daubigny recorded that his main aim at Auvers was 'to paint some rustic landscapes with figures'.[5] These included familiar themes such as washer-women working on the banks of the River Oise, but also more traditional farming scenes featuring cowherds, grape harvesters and fieldworkers. *Fields in the Month of June*, 1874 (fig.4), for example, shows labourers scything the grass and gathering produce in meadows that are alive with poppies and white chamomile flowers.

3
Charles François Daubigny
The River Seine at Mantes, c.1856
Oil on canvas, 48.4 × 75.6 cm
Brooklyn Museum, New York
Gift of Cornelia E. and
Jennie A. Donnellon

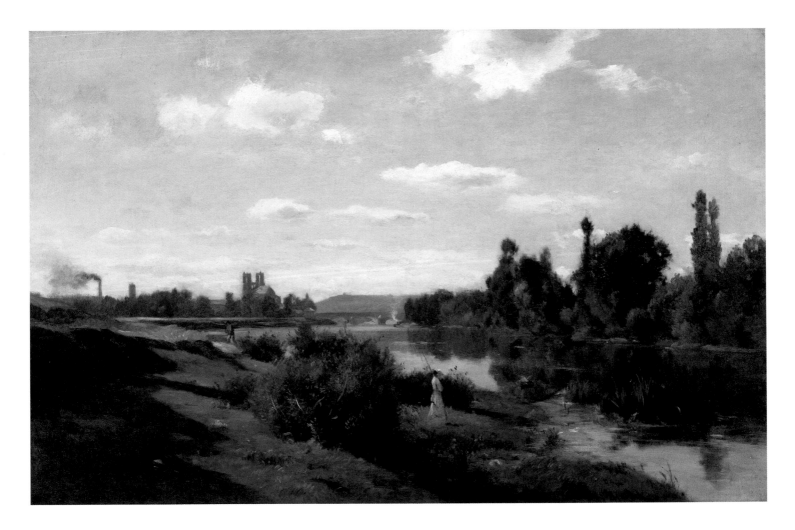

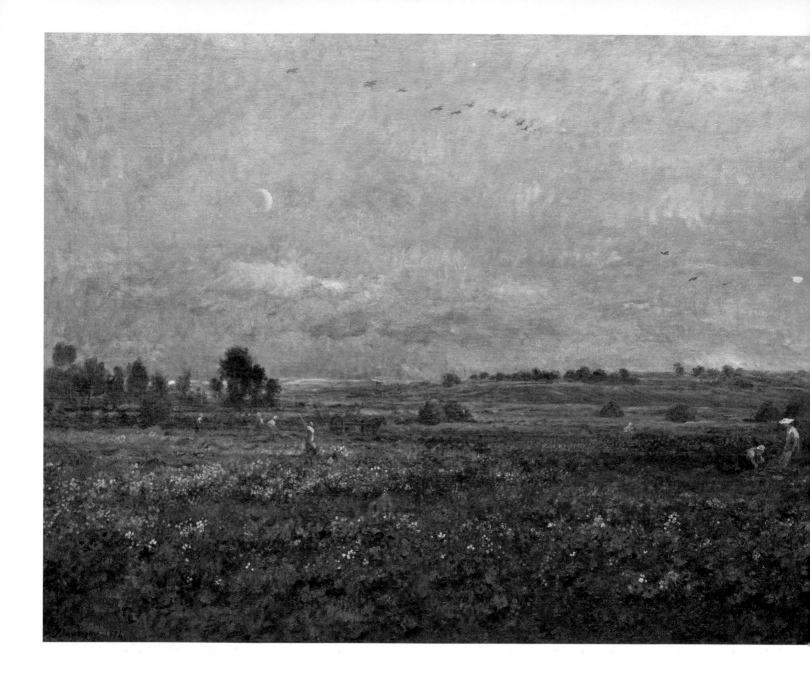

Daubigny regularly exhibited his landscapes of Auvers at the Salon and over time he achieved huge critical acclaim. He also enjoyed considerable commercial success, largely through the sale of domestic-scale variations on his Salon paintings, which were hugely popular with collectors. As a result he drew the attention of – and became an important model for – the next generation of artists.

Daubigny and Monet

Monet first met Daubigny in 1866, at Honfleur, on the Normandy coast. He had admired the older artist from as early as 1859, when he wrote to his mentor Eugène Boudin: 'Ah, Daubigny, there is a fellow who really understands nature!'[6] One of Monet's most treasured possessions was a Daubigny oil sketch of grape harvesters at twilight, which hung in the bedroom of his Paris apartment. In particular Monet admired Daubigny's breadth of handling, evident not only in his oil studies, but also in his Salon paintings.

Daubigny's influence on Monet is evident from the early 1860s onwards in works such as *Farmyard in Normandy*, 1862–3 (Musée d'Orsay, Paris), which is similar in composition and motif to Daubigny's large and atmospheric landscape of *The Mill*, 1857 (Philadelphia Museum of Art), painted at Optevoz, east of Lyon. On the other hand, it was Daubigny's views of the landscape close to Monet's home town of Le Havre that really captured the younger artist's imagination. In particular he was fascinated by one of Daubigny's submissions to the Salon of 1864, a canvas entitled *Cliffs near Villerville* (fig.5), which featured two cockle gatherers wending their way home under a leaden, rain-filled sky. Monet was sketching that summer at nearby Sainte-Adresse and produced two views of the shoreline close to the rocky outcrop known as the Pointe de la Hève.

The following year he submitted *La Pointe de la Hève at Low Tide* (fig.6) to the annual Salon, a large landscape that clearly pays homage to Daubigny's *Cliffs near Villerville*. Both canvases depict chalk cliffs, a sloping landscape and a wedge of sea under an overcast sky; and both are executed with the same breadth of handling and muted palette. According to Daubigny's biographer Frédéric Henriet, *Cliffs near Villerville* was painted in the open air. Monet, too, based his canvas on sketches made in oils out of doors, but the composition is full of carefully observed details, such as the water-filled wheel ruts

4
Charles François Daubigny
Fields in the Month of June, 1874
Oil on canvas, 135 × 224 cm
Herbert F. Johnson Museum of Art,
Cornell University, Ithaca, New York
Gift of Louis V. Keeler, Class of 1911,
and Mrs Keeler

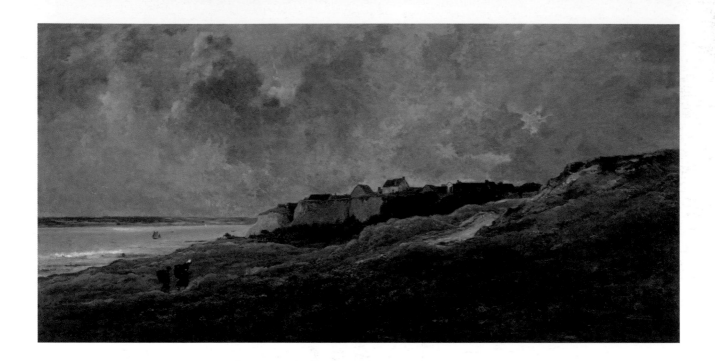

5
Charles François Daubigny
Cliffs near Villerville, 1864–72
Oil on canvas, 100 × 200 cm
The Mesdag Collection,
The Hague
(detail opposite)

6
Claude Monet
La Pointe de la Hève at Low Tide,
1865
Oil on canvas, 90.2 × 150.5 cm
Kimbell Art Museum,
Fort Worth, Texas

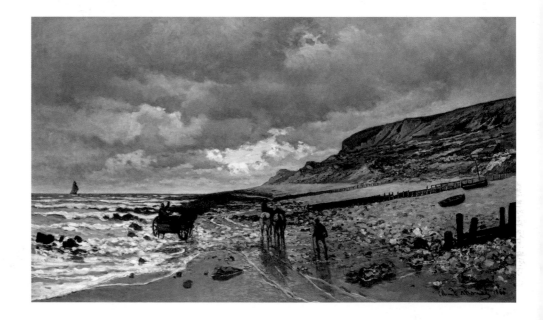

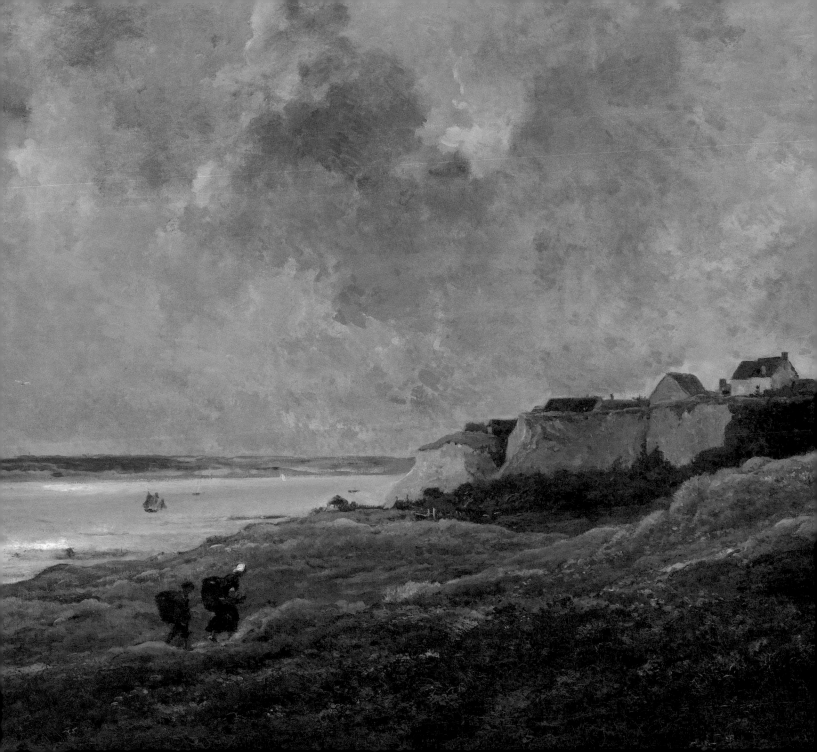

7
Camille Pissarro
The Marne at Chennevières, 1864–5
Oil on canvas, 91.5 × 145.5 cm
Scottish National Gallery, Edinburgh
Purchased 1947

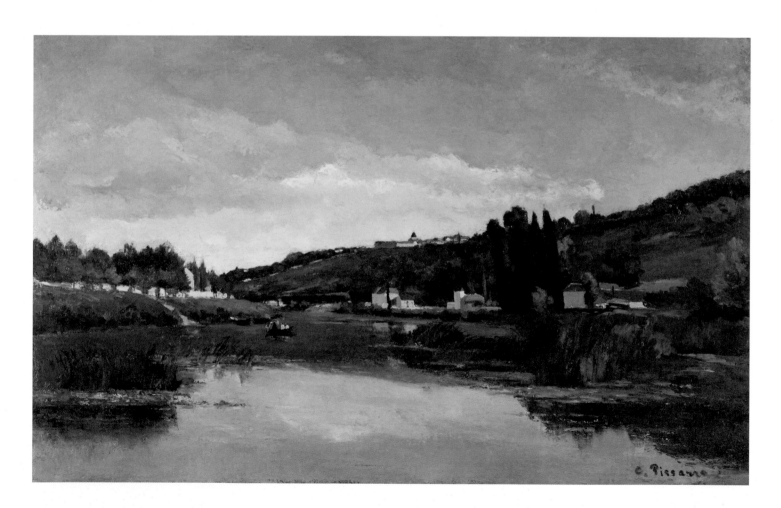

in the sand, or the smoke billowing from the chimney of a small hut on the side of the cliff.

Among the young Impressionists it was not only Monet who was strongly influenced by Daubigny. At the same Salon of 1865 Pissarro exhibited a view of *The Marne at Chennevières* (fig.7) which is close in composition to Daubigny's *Ferryboat near Bonnières-sur-Seine*, 1861 (Taft Museum of Art, Cincinnati). Pissarro adopted a similar viewpoint, from the middle of the river, and recorded the reflections in the water. He included references to modern life: the small mill on the riverbank and the woman carrying a blue parasol on the ferryboat, reminiscent of Daubigny's earlier view of *The River Seine at Mantes*.

Daubigny and Monet in London and Holland

Daubigny recognised that both Pissarro and Monet were, like himself, developing a new type of modern landscape painting and he did all he could to further their careers. In 1868 he supported their submissions to the annual Salon, along with that of Berthe Morisot. Two years later, he introduced both artists to the French art dealer Paul Durand-Ruel,

who had recently established a gallery in London's New Bond Street. With the outbreak of the Franco-Prussian War, all four men – Daubigny, Monet, Pissarro and Durand-Ruel – had fled to London for safety. While Monet and Daubigny recorded the river traffic and smoke-filled atmosphere on the Thames at Blackfriars and Billingsgate (figs 8 & 9), Pissarro, based at Lower Norwood, preferred to record suburban London in snow and sunshine.

Almost immediately Durand-Ruel began to show all three artists' work – along with that of Edgar Degas – in mixed exhibitions of French nineteenth-century art. Over the course of the next two decades Durand-Ruel would champion the Impressionists and establish a market for their work in France, Britain and the United States. Monet later recalled with gratitude that it was Daubigny who 'put me in touch with Mr Durand-Ruel, thanks to whom I and several of my friends did not starve to death. It is something I will not forget.'[7]

Daubigny's admiration for Monet is confirmed by his acquisition of one of the younger artist's paintings, *The Zaan at Zaandam*, 1871 (private collection), through Durand-Ruel. Monet visited Zaandam, in North Holland, in the summer of 1871 and was still there in September when Daubigny

8
Charles François Daubigny
St Paul's from the Surrey Side, 1871–3
Oil on canvas, 44.5 × 81 cm
The National Gallery, London
Presented by Friends of
Mr J.C.J. Drucker, 1912

9
Claude Monet
The Thames at London, 1871
Oil on canvas, 48.5 × 74.5 cm
Amgueddfa Cymru –
National Museum Wales

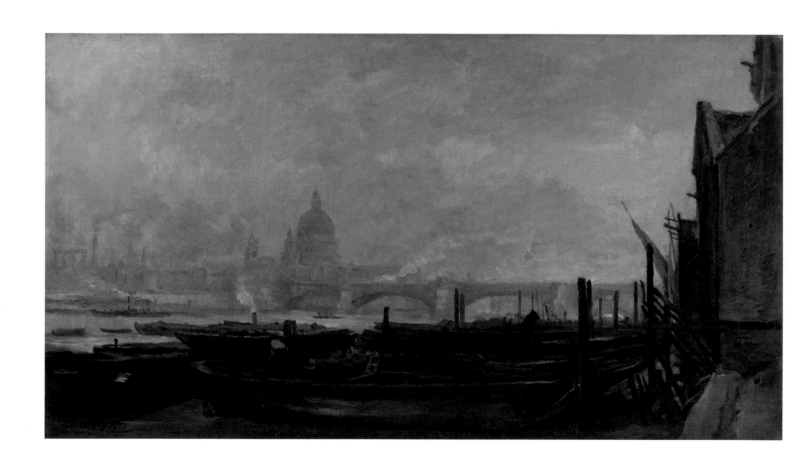

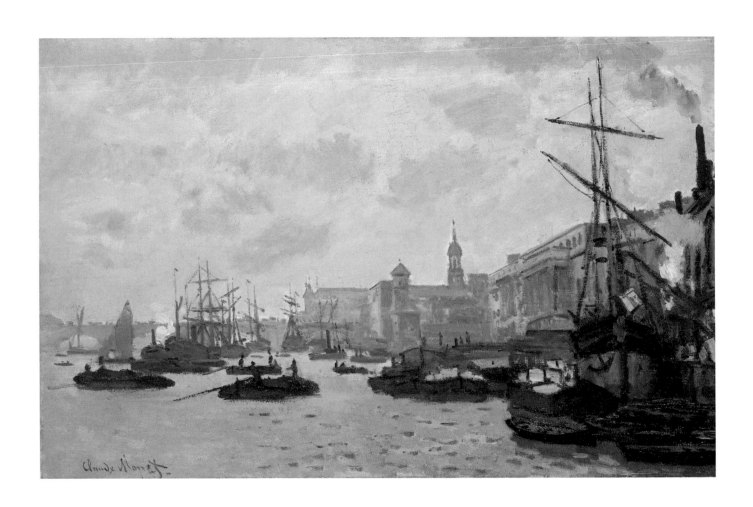

10
Charles François Daubigny
Mills at Dordrecht,
Salon of 1872
Oil on canvas, 84.5 × 146 cm
Detroit Institute of Art
Gift of Mr and Mrs E.
Raymond Field

11
Claude Monet
Windmills near Zaandam, 1871
Oil on canvas, 48.3 × 74.2 cm
Van Gogh Museum, Amsterdam
Purchased with support from the BankGiro
Lottery, Stichting Nationaal Fonds Kunstbezit,
the Ministry of Education, Culture and Science,
the Mondriaan Fund, Rembrandt Association,
the VSB Foundation and the Vincent
van Gogh Foundation

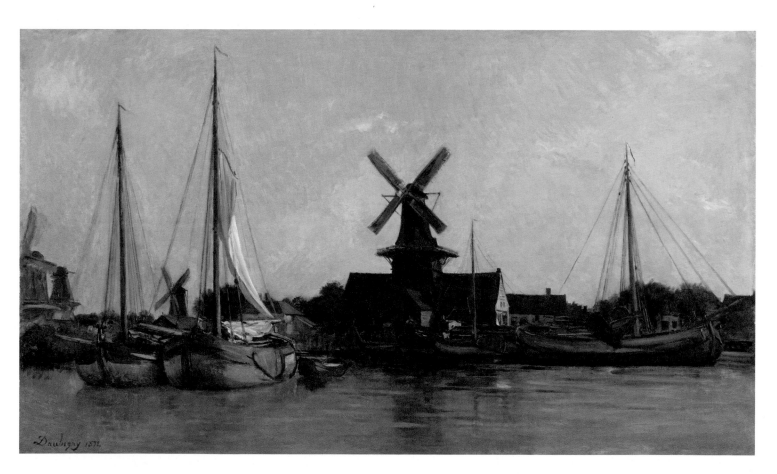

also visited the Netherlands. If one compares Daubigny's *Mills at Dordrecht* (fig.10), exhibited at the Salon of 1872, with Monet's *Windmills near Zaandam*, 1871 (fig.11), it becomes clear that Monet was already developing in a new direction. Daubigny's work, intended for exhibition in an academic forum, was completed in the studio and, while atmospheric, evokes a sense of timelessness. Monet, by contrast, worked out of doors on a much smaller canvas and employed a lighter, brighter palette. He also applied the paint with rhythmic, fragmented brushstrokes to create a sense of luminosity, movement and vibration.

Nevertheless, Daubigny continued to be an important model for Monet. On his return to France, Monet settled at Argenteuil, a popular spot for sailing, just west of Paris. He soon fitted out his own studio boat (fig.12), which enabled him to record the activity on the River Seine, as well as the changing light and atmosphere. Many of his most successful works of this period adopt Daubigny's practice of painting from mid-river, or portray an oblique view of the river and the opposite bank, as is typical of so many of Daubigny's canvases.

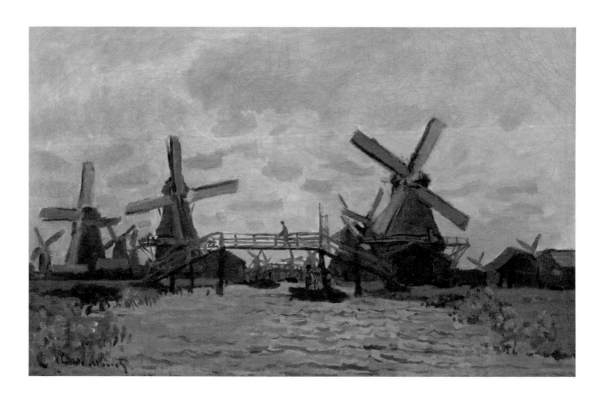

12
Claude Monet
The Studio Boat, 1874
Oil on canvas, 50.2 × 65.5 cm
Kröller-Müller Museum, Otterlo

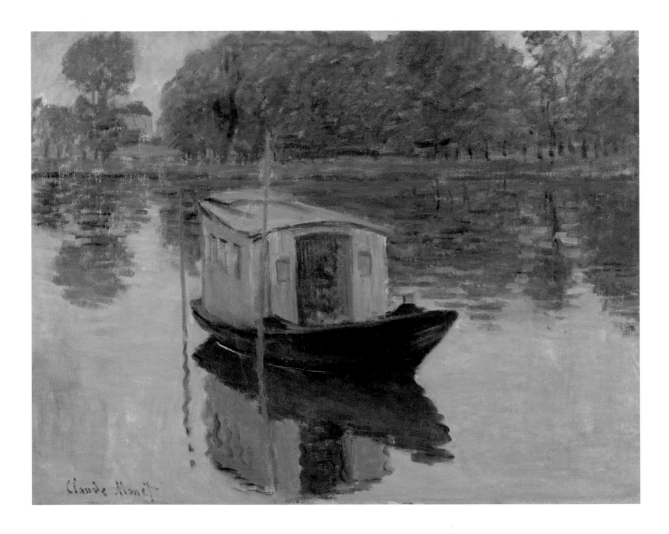

An artistic dialogue

The dialogue between Daubigny and the Impressionists was two-way, and during the 1870s the older artist began to lighten his palette and experiment with brighter, more prismatic colours. From the outset he had been fascinated by twilight effects, and at Villerville he produced repeated views of the same stretch of coastline with setting sun, anticipating Monet's later series paintings. Among the most outstanding of these late works is *Sunset near Villerville*, about 1876 (fig.14), a startlingly modern canvas, which adopts an emphatically frontal view of the ocean and explores bold contrasts of complementary blues and oranges.

For his last great masterpiece Daubigny returned to Auvers and depicted a highly romantic scene of a shepherd with his flock at twilight. The critic Emile Zola described *Moonrise at Auvers* (fig.13) as 'a magnificent painting … Night has just fallen and transparent shadows veil the fields, while the full moon rises in a clear sky. You can feel the silent quivering of evening and the last sounds of the fields as they fall asleep.'[8]

Daubigny died shortly after completing this painting in February 1878. Later that year nine of his best-known works were exhibited at the Exposition Universelle in Paris. Concurrent with this display, Durand-Ruel held an exhibition of modern French paintings, featuring a large number of works by Daubigny. The show was seen by, among others, Monet, whose response is clear in several of the works that he produced around this period. He had reached a transitional stage in his work and was finding it difficult to sell his paintings. As a result he was suffering from financial problems, exacerbated by his wife Camille's illness and subsequent death. Daubigny had enjoyed considerable commercial success towards the end of his career, and Monet looked to his landscapes for inspiration. He also began to resubmit work to the official Salon.

Daubigny's influence on Monet is clearest in two large canvases of 1880: *The Seine at Lavacourt* (fig.16) and *Sunset on the River Seine at Lavacourt, Winter Effect* (fig.15). The latter looks back to Monet's *Impression: Sunrise*, 1872 (Musée Marmottan Monet, Paris) – the work that gave its name to the Impressionist movement – but also evokes Daubigny's own atmospheric sunsets on the Oise; the former, with its oblique view of the river, recalls the composition of works such as Daubigny's *The Village of Gloton* of 1857 (The Fine Arts Museums of San Francisco) and countless views of a similar type which, as Monet realised, were highly marketable.

What differentiates Monet from his predecessor is his high-keyed impressionist palette and flickering brushstroke, which unifies the surface of the canvas.

13
Charles François Daubigny
Moonrise at Auvers, also known as
The Return of the Flock, 1877
Oil on canvas, 106.5 × 188 cm
The Montreal Museum of Fine Arts
Gift of Lady Drummond in memory of
her husband, Sir George A. Drummond

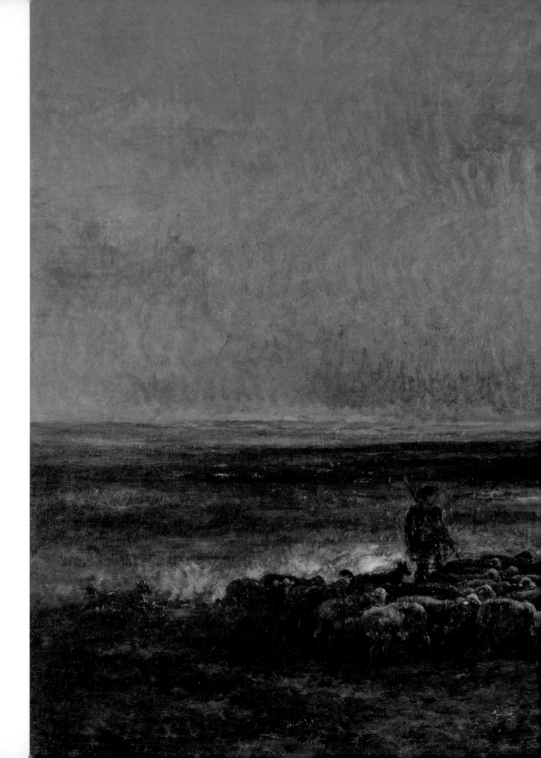

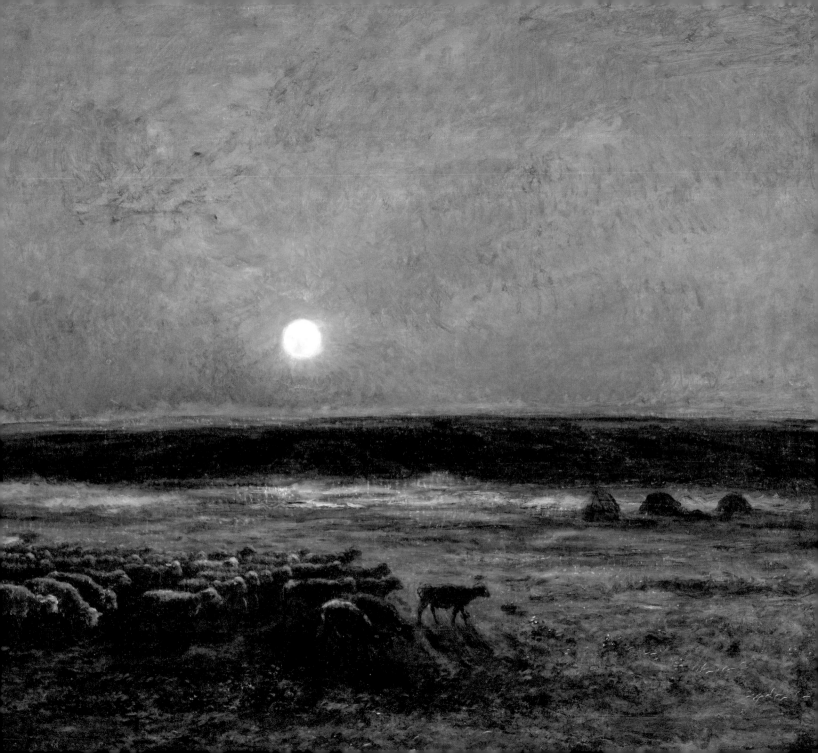

14
Charles François Daubigny
Sunset near Villerville, c.1876
Oil on canvas, 89 × 130 cm
The Mesdag Collection,
The Hague

15
Claude Monet
**Sunset on the River Seine at
Lavacourt, Winter Effect**, 1880
Oil on canvas, 100 × 150 cm
Petit Palais, Musée des Beaux-Arts
de la Ville de Paris

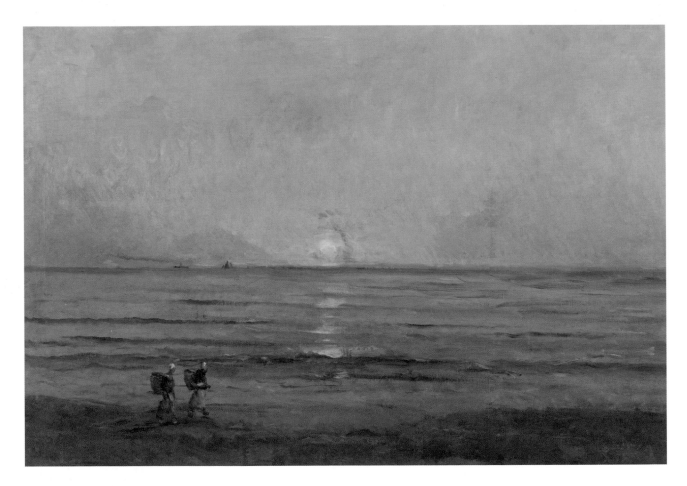

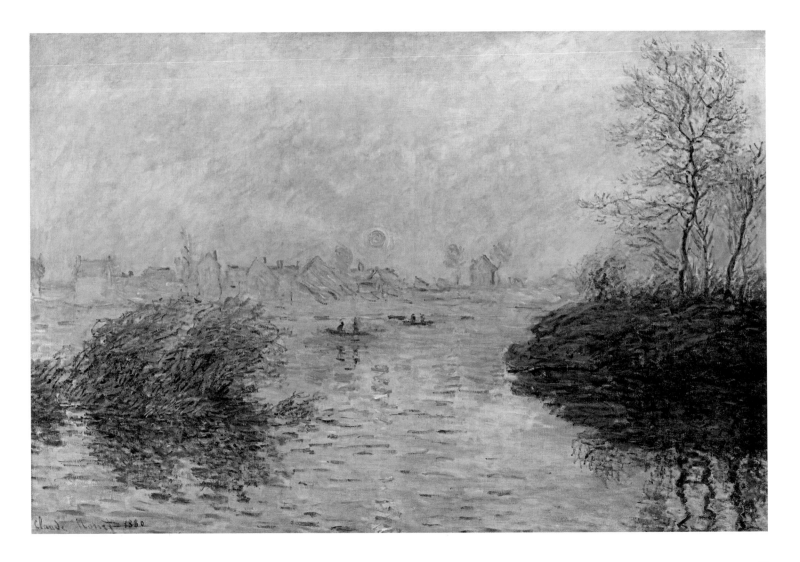

16
Claude Monet
The Seine at Lavacourt, 1880
Oil on canvas, 98.4 × 149.2 cm
Dallas Museum of Art
Munger Fund

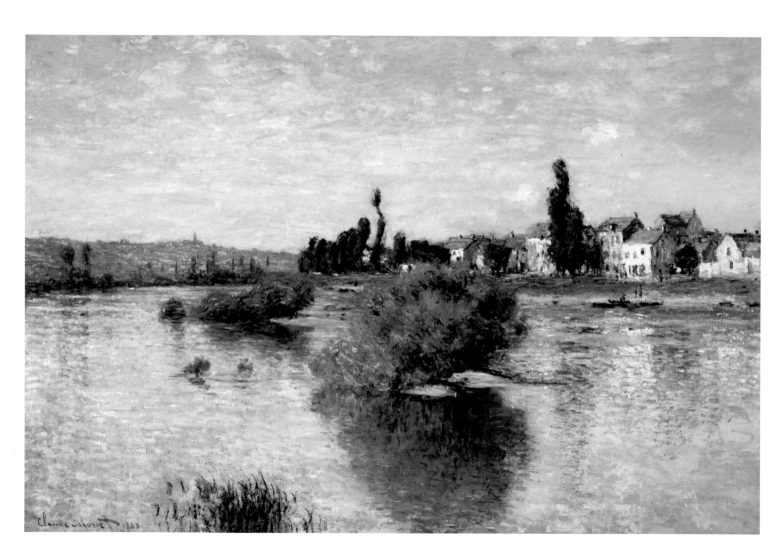

Furthermore, the works painted from Monet's studio boat give the viewer the impression of being truly immersed in nature, rather than simply observing it. Nevertheless, the older artist remained an important and crucial inspiration, and it was only through Daubigny's example that Monet discovered the route to Impressionism.

Daubigny and Van Gogh

Apart from Monet, the artist who most admired Daubigny was Vincent van Gogh. Van Gogh identified with Daubigny's concern for naturalism and 'truth to life' and regarded him as one of the pioneers of modern landscape. In his view, the artists of the Barbizon School, with whom Daubigny was closely associated, were the true successors to Dutch seventeenth-century masters such as Jacob van Ruisdael and Jan van Goyen.

Van Gogh probably encountered Daubigny's work for the first time while working for the art dealers Goupil in The Hague, where he lived from 1869 until 1873. He returned to the city in 1882 to work alongside his cousin by marriage, Anton Mauve, a leading member of the group of artists known as the Hague School, who painted out of doors and focused on naturalistic subjects such as the fisherfolk at nearby Scheveningen or the farming community at Laren in North Holland. On one occasion Van Gogh visited an exhibition of French realist painters in The Hague and was struck by a canvas by Daubigny of 'big thatched roofs against the slope of a hill'. He wrote to his brother Theo that he 'couldn't get enough of' that painting – a view of Auvers where, although he little realised it at the time, he would spend the last two months of his life.[9]

Daubigny continued to be a point of reference for Van Gogh, and when he moved to Paris in 1886 he hung a Daubigny etching *Dawn, Cock Crowing* in his room. At the Musée du Luxembourg he was able to see and admire works such as Daubigny's *Spring*, 1857 (fig.17), one of Daubigny's earliest canvases showing apple trees in blossom. Daubigny regularly exhibited paintings of orchards, perhaps intended as a symbol of France's fecundity. Both Monet and Pissarro were inspired to follow suit and during the 1870s they created a whole series of paintings on this theme (fig.19). Not surprisingly these bright and optimistic canvases, symbolising new growth and regeneration, were well received during the period following the Franco-Prussian War.

Charles François Daubigny
Spring, 1857
Oil on canvas, 96 × 193 cm
Musée d'Orsay, Paris, on loan
to the Musée des Beaux-Arts,
Chartres

The cycle of the seasons was something that fascinated Van Gogh, and when he moved to Provence in 1888 he, too, began to paint canvases of blossoming plum and apricot trees (fig.18). These flowering orchards reminded him of Japanese prints and he painted them in heightened colours, reflecting his own feeling of optimism at this time. For Van Gogh the blossoms symbolised spring, regrowth and new life. He described to his friend the artist Emile Bernard how he used 'no system of brushwork at all; I hit the canvas with irregular strokes which I leave as they are, impastos, uncovered spots of canvas – corners here and there left inevitably unfinished – reworkings, roughnesses'.[10] In this way he captured the effect of sunlight on the trees and used countless tiny dots of impasto to denote the petals trembling in the breeze.

After spending two years in Provence, one at the asylum in Saint-Rémy, Van Gogh moved to Auvers-sur-Oise. Pissarro had recommended the village to Theo, due to the presence there of Paul Gachet, a homeopathic doctor who was an amateur

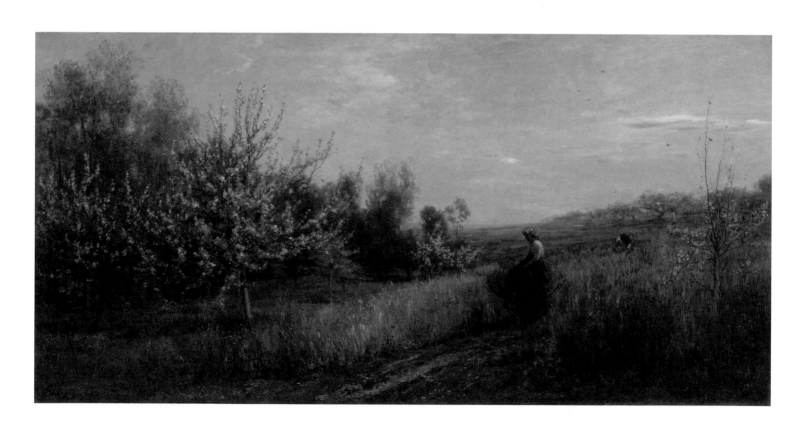

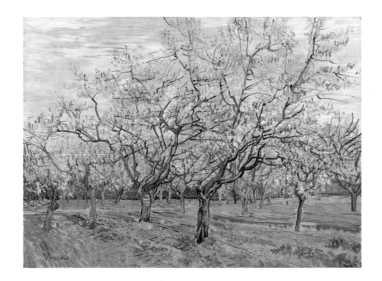

18
Vincent van Gogh
The White Orchard, 1888
Oil on canvas, 60 × 81 cm
Van Gogh Museum, Amsterdam
Vincent van Gogh Foundation
(detail overleaf)

19
Claude Monet
Spring (Fruit Trees in Bloom), 1873
Oil on canvas, 62.2 × 100.6 cm
The Metropolitan Museum of Art,
New York
Bequest of Mary Livingston
Willard, 1926

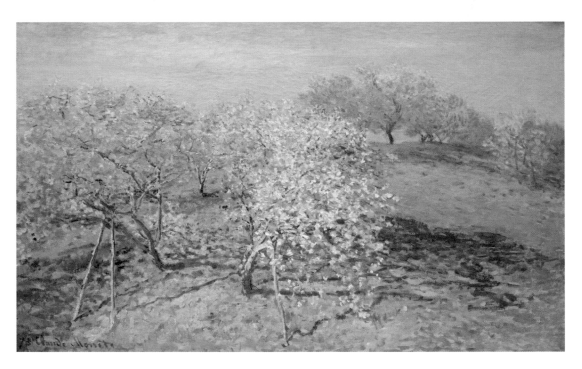

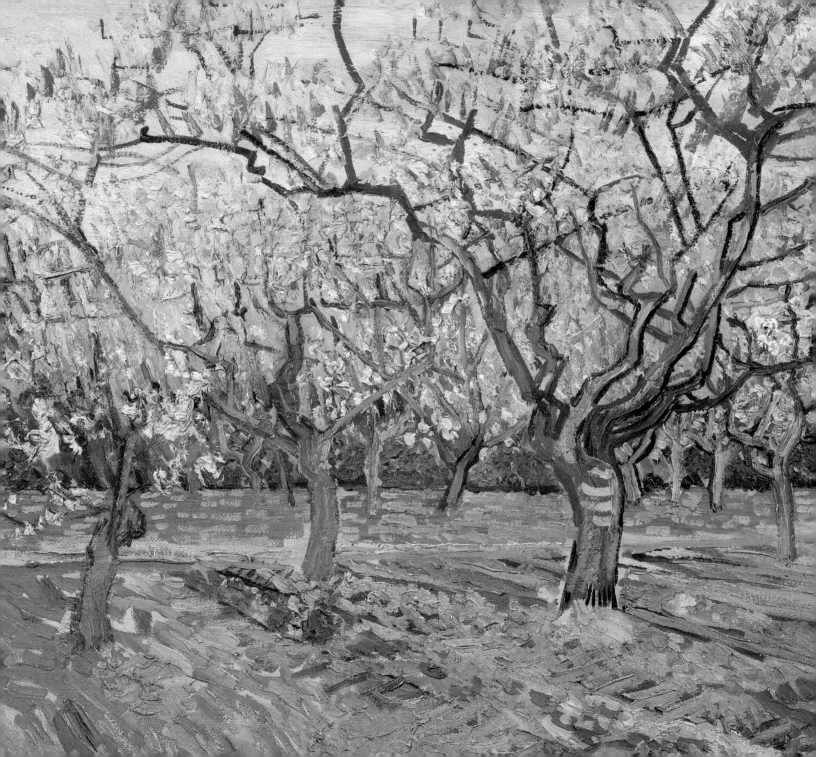

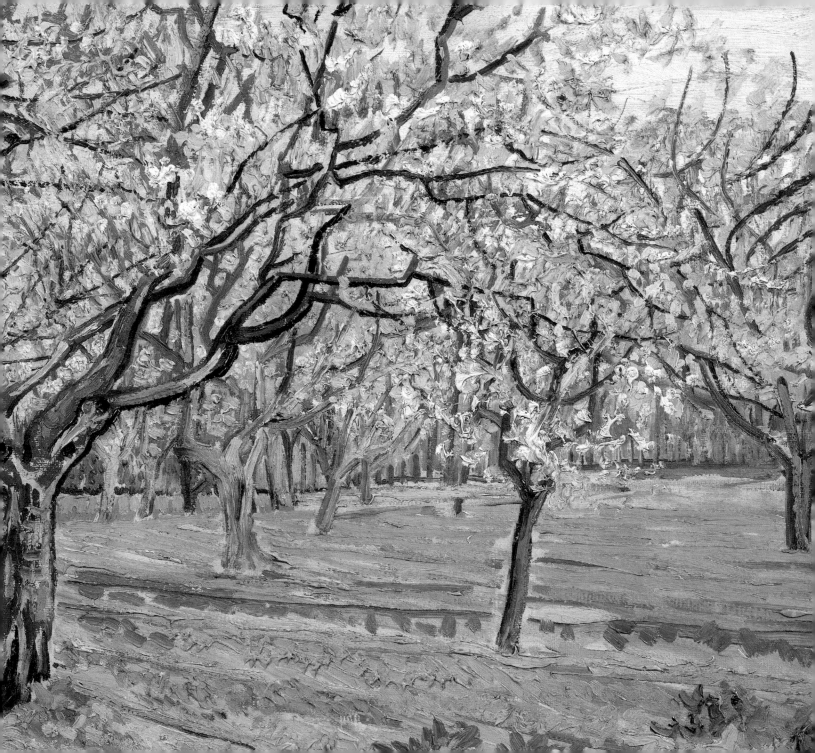

artist and an early supporter of the Impressionists. Van Gogh, like Daubigny, was attracted to the area because it was unspoiled, a tranquil haven from the modern world. Perhaps he still recalled Daubigny's painting of the cottages of Auvers that had so inspired him in The Hague. Yet, by the time he moved there, modern houses were already replacing the traditional thatched dwellings and a new railway had been built at Chaponval. Nevertheless he maintained his optimism and wrote to Theo that the village had 'changed since Daubigny. But not changed in an unpleasant way … no factories, but beautiful greenery in abundance.'[11]

Like Daubigny he was enchanted by the 'many old thatched roofs' which, he noted, were 'becoming rare'.[12] He painted the traditional houses and the wheatfields above the village and on one occasion came upon a field of joyful poppies, which he transformed into a swirling mass of complementary red and green brushstrokes (fig.21). These same

20
Claude Monet
Field with Poppies, 1881
Oil on canvas, 58 × 79 cm
Museum Boijmans Van Beuningen, Rotterdam

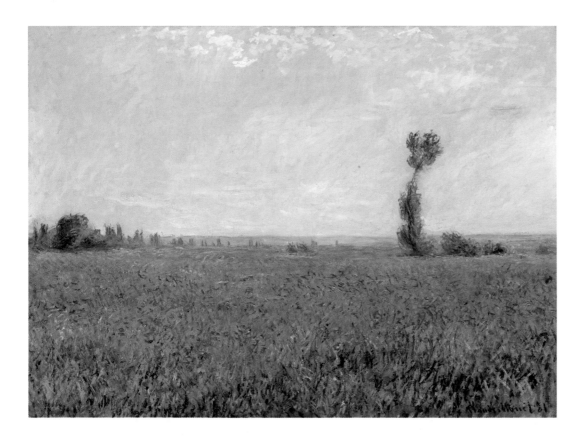

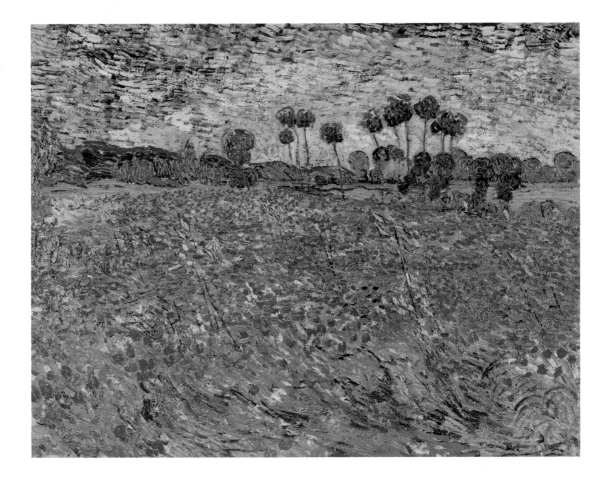

21
Vincent van Gogh
Poppy Field, Auvers-sur-Oise, 1890
Oil on canvas, 73 × 91.5 cm
Gemeentemuseum, The Hague
Loan Cultural Heritage Agency
of the Netherlands

poppy fields had been recorded by Daubigny and were a favourite theme in Monet's art (fig.20). Indeed the subject had been highly commercial for both artists, and Van Gogh almost certainly had this in mind when he painted his own canvas.

Van Gogh also followed Daubigny's example when he embarked on a series of landscapes in a new 'double square' format. This was an approach pioneered by Daubigny in many of his oil sketches, for it enabled him to take in a wide sweep of the landscape. Appropriately Van Gogh used it for one of his final canvases, a view of Daubigny's house and garden (fig.22).

Although Daubigny died well before Van Gogh moved to the village, his widow was still living there, and was happy to allow the Dutch artist

Vincent van Gogh
Daubigny's Garden, 1890
Oil on canvas, 50 × 101.5 cm
Collection Rudolf Staechelin

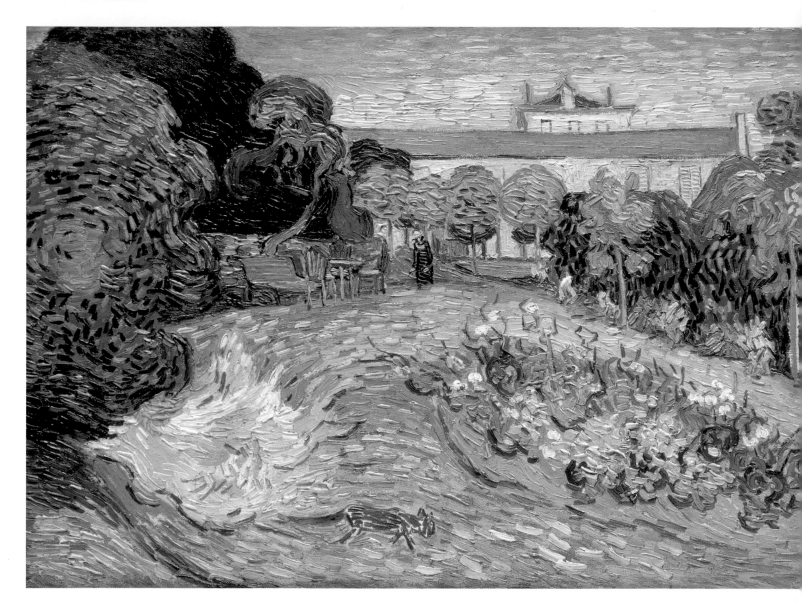

to set up his easel in her garden. Daubigny had acquired the house just before he died, so never lived or worked there. Nevertheless the painting became Van Gogh's homage to the artist he had admired throughout his career. In the large composition he showed the whole of the house and a section of the garden, with Madame Daubigny in the background and a black cat in the foreground. In his last letter to Theo, written on 23 July 1890, he made a sketch of the painting, which he described as 'one of my most deliberate canvases'.[13]

In the end Van Gogh produced twelve of these horizontal canvases, among which are some of the most expressive and emotionally charged works of his entire career. They included the *Wheatfield with Crows*, 1890 (Van Gogh Museum, Amsterdam) which, painted in stabbing brushstrokes of brilliant yellow and deep blue, shows crows hovering above the ripening wheat under a threatening sky. In his final letter to Theo, Van Gogh described this and another similar canvas as 'vast fields of wheat under troubled skies … I did not need to go out of my way to try to express sadness and extreme loneliness.'[14] Four days later he walked out into the wheatfields under an intense summer sun and shot himself in the chest. He died two days later.

Conclusion

Despite Van Gogh's struggle with life, he presented, in the main, an optimistic view of France as prosperous and richly verdant. This was something he shared with both Monet and Daubigny, whose orchard paintings likewise symbolise springtime and renewal and whose wheatfields represent abundance and fecundity. Theirs was an artistic dialogue which spanned thirty years, from the early 1860s to the end of Van Gogh's short life. It was Daubigny who led the way: his frank naturalism, bold compositions and technical innovations providing inspiration for the next generation of artists. Today he deserves to be remembered, not only for inventions such as the studio boat, but for his crucial contribution to the development of modern landscape painting. For it was only through the example of pioneers like Daubigny that artists such as Monet and Van Gogh were inspired to work in new and innovative ways.

Notes

1 Léon Lagrange, 'Le Salon de 1864', *Gazette des Beaux-Arts*, vol.17, no.1, 1 July 1864, pp.5–44.

2 Etienne Moreau-Nélaton, *Daubigny raconté par lui-même*, Paris, 1925, p.81.

3 Pierre Henri de Valenciennes, *Elémens de perspective pratique à l'usage des artistes*, Paris, 1799, p.520. Author's translation.

4 Emile Zola, 'Le Salon de 1876', *Les cahiers naturalistes*, http://www. cahiers-naturalistes.com/pages/ Daubigny.html (accessed 11 April 2015). Author's translation.

5 Van Ryssel (alias Paul Gachet), 'De Daubigny à Van Gogh: Les artistes à Auvers', in Roger Golbéry, *Mon Oncle, Paul Gachet*, Paris, 1990, p.184.

6 Letter dated 3 June 1859 from Monet to Boudin. Reproduced in Gustave Cahen, *Eugène Boudin, sa vie et son oeuvre*, Paris, 1900, pp.24–7.

7 Monet in a letter to Etienne Moreau-Nélaton, 14 January 1925, quoted in original French in John House, 'New material on Monet and Pissarro in London in 1870–71', *The Burlington Magazine*, vol.120, October 1978, p.636.

8 Dominique Fernandez (ed.), *Le Musée d'Emile Zola: haines et passions*, Paris, 1997, p.171.

9 Letter 246 to Theo van Gogh, The Hague, 15 and 16 July 1882. The Van Gogh correspondence is available online at vangoghletters.org/vg/.

10 Letter 596 to Emile Bernard, Arles, on or about 12 April 1888.

11 Letter 875 to Theo and Jo van Gogh-Bonger, Auvers, 25 May 1890.

12 Letter 873 to Theo and Jo van Gogh-Bonger, Auvers, 20 May 1890.

13 Letter 902 to Theo van Gogh, Auvers, 23 July 1890.

14 Ibid.

Published by the Trustees of the National Galleries of Scotland to accompany the exhibition

Inspiring Impressionism: Daubigny, Monet, Van Gogh

held at the Scottish National Gallery, Edinburgh, from 25 June 2016 to 2 October 2016.

Exhibition also shown at:
Taft Museum of Art, Cincinnati from 20 February 2016 to 29 May 2016
Van Gogh Museum, Amsterdam from 21 October 2016 to 29 January 2017

Text © 2016 the Trustees of the National Galleries of Scotland

ISBN 978 1 911054 00 9

Printed on 150 gsm Claro Bulk by Gomer Press Ltd
Designed and typeset by Philip Lewis

FRONT COVER Charles François Daubigny, *Moonrise at Auvers*, also known as *The Return of the Flock*, 1877 The Montreal Museum of Fine Arts (detail of fig.13)

TITLE PAGE Charles François Daubigny, *Spring*, 1857 Musée d'Orsay, Paris, on loan to the Musée des Beaux-Arts, Chartres (detail of fig.17)

BACK COVER Claude Monet, *Spring (Fruit Trees in Bloom)*, 1873 The Metropolitan Museum of Art, New York (detail of fig.19)

This exhibition has been made possible with the assistance of the Government Indemnity Scheme provided by Scottish Government.
National Galleries of Scotland is a charity registered in Scotland (no.SC003728)

Copyright and Photographic Credits